GARDENST

Martin Malone now divides his time between Donegal, Aberdeenshire and France. He has published four poetry collections: *The Waiting Hillside* (Templar, 2011), *Cur* (Shoestring, 2015), *The Unreturning* (Shoestring 2019), *Gardenstown* (Broken Sleep Books 2024) and *a Selected Poems 2005 – 2020: Larksong Static* (Hedgehog 2020). He's also published 4 pamphlets: *17 Landscapes* (Bluegate Books), *Prodigals* (The Black Light Engine Room), *Mr. Willett's Summertime* (Poetry Salzburg), *Shetland Lyrics* (Hedgehog). He is an editor at *Poetry Salzburg Review* and a Poetry Ambassador for the Scottish Poetry Library.

Bryan Angus is an Aberdonian who now lives in Banff on the north Aberdeenshire coast. For many years he ran an art retreat in Gardenstown with his wife Carla, where he re-learned how to make pictures. His great pleasure is landscape - whether that's painted, drawn or printed - and finding the stories that are held in the fabric of the land. He currently enjoys making his own work for exhibition, as well as illustration and design for commercial projects.

Also by Martin Malone

Larksong Static: Selected Poems (2005-2020) (Hedgehog, 2020)

The Unreturning (Shoestring, 2019)

Cur (Shoestring, 2015)

The Waiting Hillside (Templar, 2011)

CONTENTS

ISBN: 978-1-916938-10-6

Cover designed by Aaron Kent

Cover image by Bryan Angus

Edited and Typeset by Aaron Kent

Broken Sleep Books Ltd
PO BOX 102
Llandysul
SA44 9BG

For Jenn, Fionn, & Laika

Gardenstown

Martin Malone
&
Bryan Angus

Broken Sleep Books

PREFACE

In the summer of 2017, we moved from our flat in Aberdeen to a quirky old house on the seafront at Gardenstown, a village, snug to the cliffs of the Banffshire coast. Visiting in 1971, George Mackay Brown described the town as 'being built on four or five levels from the cliff top to the sea edge' and 'one of the strangest places in Scotland, a tribute to men in their struggle with the vertical'. While I don't see it as 'strange', I do sense a certain Milk Wood magic in this wee town, facing north towards what feels like the edge of the world. One is spoilt for choice of daily wonders right here on our doorstep, and it yet feels like there's a fragile ecosystem hanging on in the face of climate catastrophe. I suppose this inescapable context for the whole of contemporary life right now, is what makes *Gardenstown* an 'eco-poem' of sorts, though in the same broad sense that Edward Thomas's work is seen as 'war poetry'. Great disasters tend to creep up on us in the smaller details of our daily lives: the lifeless rock pool, a poisoned raptor, unseasonal blossom, the dead auks strung out along the shoreline. Similarly, *Gardenstown* is not a 'pandemic poem', though its prolonged act of looking was, to a large extent, facilitated by lockdown in the bay. The poem's short, ebbing lines are, then, meant to suggest the tide on the narrow strand here, how it moves quickly sweeping detail in and out of itself. It's these we ignore to our cost.

— *Martin Malone, Gardenstown, December 2021.*

I started making images of Gardenstown around 2005 while teaching visitors how to paint and draw the compositional feast that is there. The extraordinary perspectives and shapes do fascinate me but more importantly the story of the village and its people is undisguised and can be read clearly in every corner. Modern settlements smother or erase the shape of the land it is built on, hide how the fabric of buildings are put together. In Gardenstown each building is as individual as people, you can touch the stones hefted by hand into a wall, count the endless steps that snake up and down, and climb the natural bones of the land that protrude from cliffs or harbour walls. I can't imagine getting bored of it.

— *Bryan Angus 2022*

'...immanence and transcendence co-constitute each other through the everyday interaction of words, bodies, and material objects.'
— Joseph Webster, *The Anthropology of Protestantism: Faith and Crisis among Scottish Fishermen,* 2013)

I. NOCTURNE/ AUBADE

Where to begin but night
as high tide, lush with kelp,
licks at the harbour wall
and a lone oystercatcher
ghosts its underside out
beyond the pier's crook.
A scrum of small boats
hunker on the breath
of the swell's accordion
and chimes of halliard
on staysail toll this midnight.
From the pier-end saltire,
turn to see the small town
fold itself into the brae
beyond the quayside,
snake in soda-light up

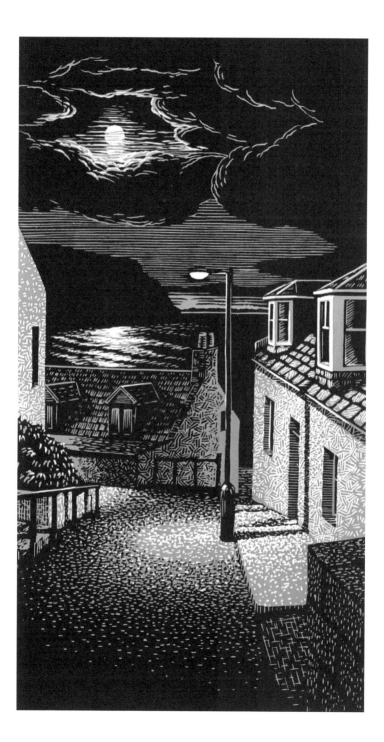

towards the Free Church,

on past the Dreel Hall

and shop, to the warmth

of upper-town bungalows,

where native Gamrie sleeps

in its Doric entitlement.

Let your gaze wander back

to a sea pinned with starlight

and washed in moon-silver,

stained with alluvium

from the day's storm.

Deep in the shore's bones,

the tide's abiding question

remains unanswered, as waves

milk the cliffs of their foam,

and the bay's gargled vowel

is rinsed in their wake.

Listen closely and you will hear

the hollow pock of pebbles

under the draw of backwash,

as the swell smooths out its folds

on Gardenstown beach

and time pauses upon

the lone comma of a seal snout

punctuating the night's rucked

canvas. Back to Seatown,

where the light's asklint

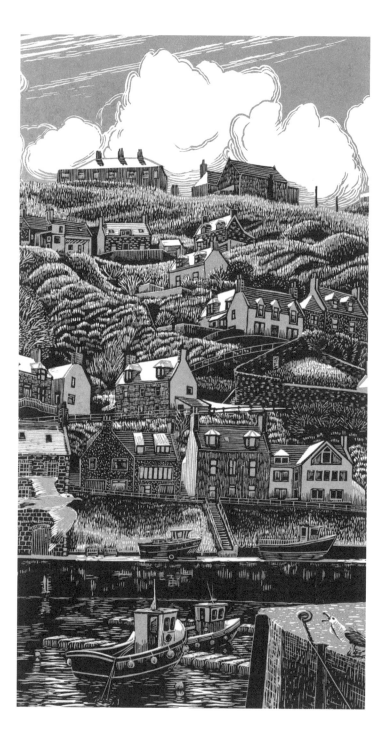

in *Harbour Cottage*, Zander's
silhouette bidding farewell
to his wine-wasted Juliet.
Watch him stagger, the reel
of this versioned drunk:
a poor wandering *mannie*
adrift on his intemperance.
Tomorrow, he will wake
to the tide's reaffirmation,
to the hiss between its teeth
and the day's new music
brogued into being
by these dialects of water.
The moon overprints itself
upon the block of this night,
sheens sillion onto roof slate
and ghosts among the lanes
of the sleeping town.
For now, it's time to go
dispel the klatch of redshank
jittering on the wharf,
to stroll its landward length
and take this seeing home
to a sleeping child and mother
wrapped in one another,
aground on the skerries
of their shipwreck dreams.

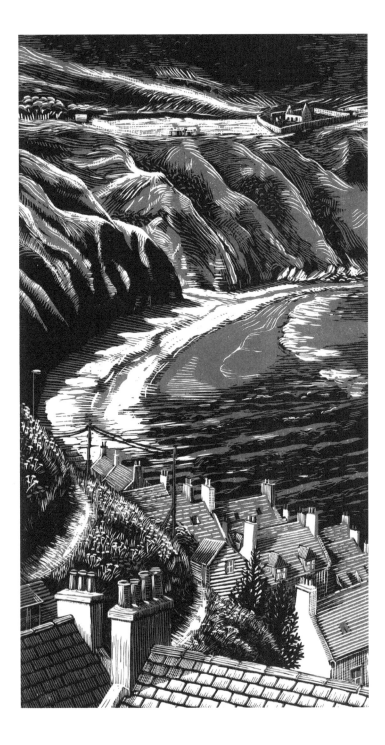

Dawn gifts the sea's slow prism

and the lumen hours

of a northern shore

always at my shoulder,

always prone to rain,

the drawn line of horizon

stretched across a bay

the gods died making,

and morning's urgent grave

upon the gable end

trimming the void to light

as another day answers for itself.

How it alters colour, how it

makes and unmakes shadow,

how it comes ready-made

by morning to the folded cliffs,

drawing at the core of it all,

as the winter sun's candela

scorps the six-hour day

from the hollow of my palm,

thumb along the blade,

resurfacing the light:

everything feeds into this.

II. SUMMER

Sunk beneath the hot midday,
this bay affirms its integrity –
some sense of filigreed coherence
held fast against the tide.
The sky's unreachable view
shifts light from nowheres
into celandine and orchid
as form shows itself pristine
yet mute to its own meaning,
a collie's sea-shook rainbow
sheds inertia onto sand and
we unpack the day's intention.
Is it for this we live, our boy
hacking fiefdoms from the air
in the haze of an afternoon
while his first dog drops

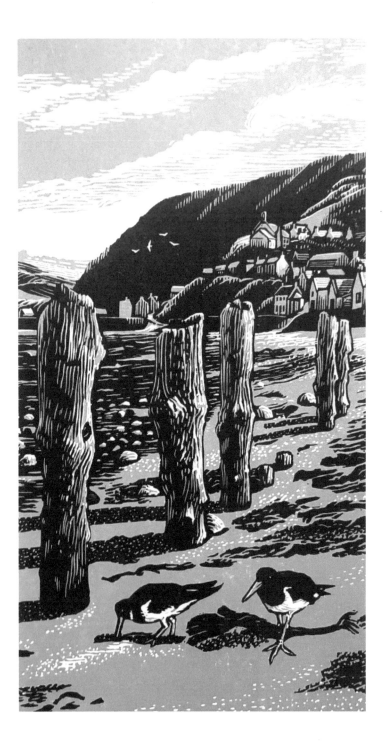

driftwood at your feet?
The moment is its own country
slipping past thought, or what
passes for thought, towards
this quantum of Summer;
can no more be touched
than the sky's endless blue
yet is real somehow, somehow
meets its own need to find
equivalence in these rocks
and us and now. Here,
under plough-line corduroy,
on this horseshoe strand
below the Mohr's green pelt,
the landscape holds us fast
within the ambit of its mood;
finds design in the deep impasto
of a hot afternoon, as I mark
the freckles plotting their way
up the pale skin of your arm.
A stonechat's kenspeckle rose
flits into view then off again,
ignites the eye to slant of shale
and the sheer immanence
held within this warm air
of the year's one good day
that is gifted with stillness.

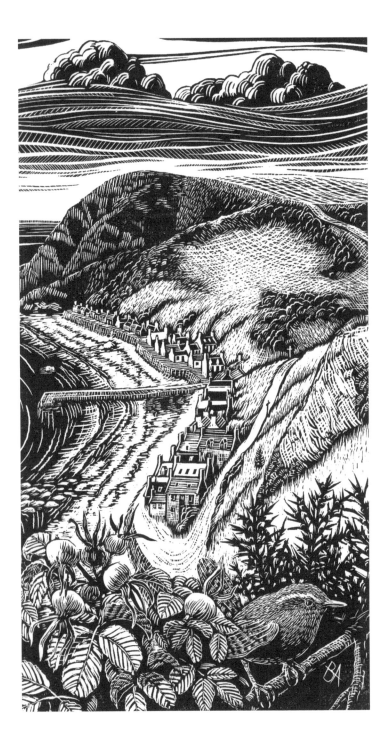

Sea becomes sky in this
too-much-light, the horizon
a drum-skin stretched across
the bay and something lives
that is yet not life but rubs
against your own heartbeat.
From here, we look back
across the sand to morning,
where the topple-down score
of our sad little town ad-libs
its wistful jazz to the sea,
while a trace of us yet wrestles
with the old blue door askew
on its hinge. The heather's ablaze
above Crovie, its screen of heat,
collapsing the landscape beyond,
folds the fields of the Five Farms
into wavering haunts as far
as the clifftops at Troup.
About us, wildflowers hold
their breath in the swelter
as the bay's wee boats are
squeezed to near nothings
by the glitter of sunlight
on water and the landfall
of Caithness seems but
a few hours' stroll across

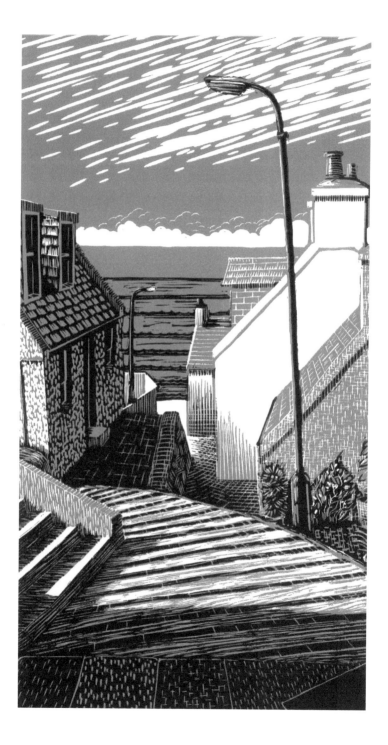

its glimmering surface.

At five, we pack our things,

haul our boy from the surf

and tramp past Swallow Rock,

the burn, then onto the Biggin

where we thread the Quarry Path

home through back lanes

heady with honeysuckle.

From someone's kitchen,

a radio plays Test cricket,

the air cedes nothing but itself,

and, sunk in its own motion,

the sea reasserts abstraction

while these moments slip

the anchorage of fact,

losing their loveliness as

the day yields brilliance

to the slow onset of dusk

and this town of bonnie sunsets

gives another to our season.

III. AUTUMN

Already, cumulus piles high
against the morning, as,
beak tug-full of carrion,
the season starts with crows
and six dead guillemots
garnishing the tide line.
Daybreak runs beside me over
sand and fetid kelp; stares back
across the bay to Crovie Head,
where a low haar traps
then turns to ghost the light.
Greys edge out the far north's
sunken tones and attention
is required to see a second Spring
dormant in these finer days
of late September. This is no

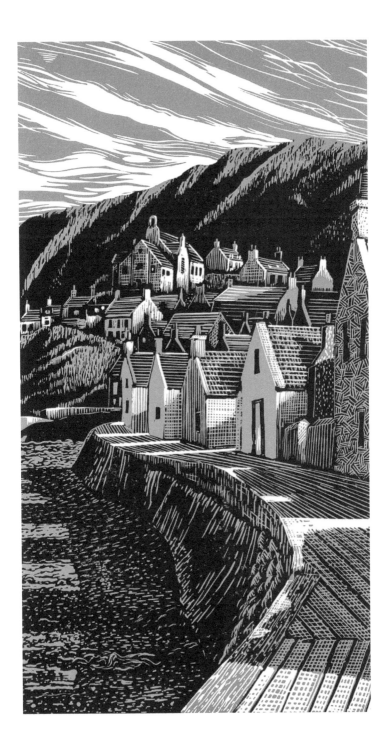

immense thing but a subtle one

which speaks of love and the way

we're caught in our moment

as vividly as mammoth calves

in ice, while the honeysuckle

outstares God from the braes

of Castle Hill. In the town,

its streets grow quiet now:

the rentals peter out to rain,

Quiz Night's back in the Arms Hotel,

Steve takes stock in *The Wee Shoppie*

and Jane moves up into *Westerhall*,

with her whippet and home-made

coffin, like some Egyptian queen.

Dawn fruits a fat white moon

hung low above St. John's

as the bay blooms its trawlers

about their business of squid

and the year's last flourishings

of mackerel. Teatime's a spindrift

of baltering bairns home from Bracoden,

while sunset is kestrel-feathered,

hovering its greys and marigold

out above the banks of Law Hill.

The tide moves quickly, sweeping

detail in-and-out of itself

while waders follow its flow:

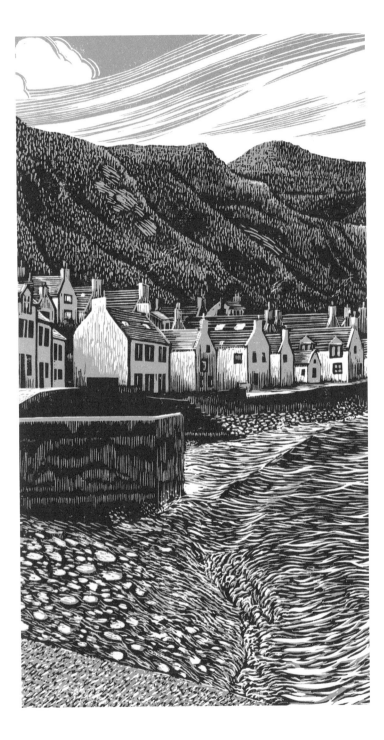

redshank, turnstone, oystercatcher,

and knot; the odd lorn curlew

gathering about itself absence

and some vague glim of eviction.

Throughout the night, pink-footed

geese hit landfall in ragged skeins

from Iceland, bound for Strathbeg;

their song a stramash of wild telling

renewing the host's adherence,

while we, too, replenish and reset

for the cold days ahead, hushed in

the year's twilight. October ends

in a swag of blue netting and boats

craned from the harbour to sit out

the squalls of a filsket sea; on days

like these when the light lies so low

to the ground it lacks direction,

objects elide one into the other

and the Mohr is a state of mind

that will not be explained.

Autumn tides rake the Braid Sands,

lengthening those thin shadows

cast by the storm-spared Apostles;

set down tree trunks, hanks of tangle,

and the lone rubber glove put ashore

beside the innards, feather-and-bone

of a decommissioned gull.

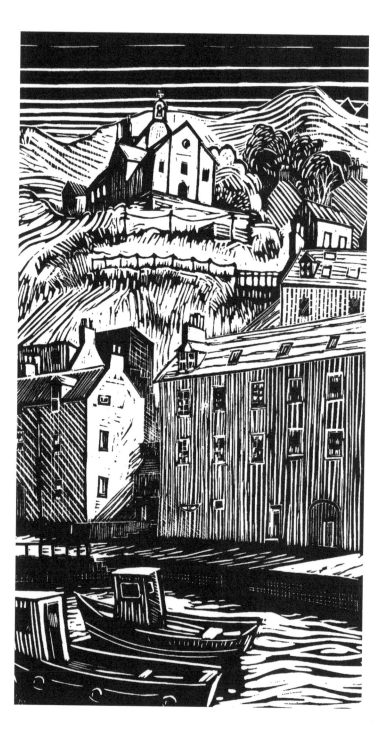

This is the season of *aurora*
shifting in the high latitudes,
of *Ursa Major* snouting the dark
above the bay while we set fires
to burn long into the night.
And through it all, saved Gamrie
settles down to pray, bible in hand;
its best-suit Sunday sat in kirk
or chapel, witnessing The Word
and waiting upon *eschaton* to the
doleful note of an electric organ
in the Gospel Hall, or Free
Protestant Church of Ulster.
All is here though not all called
to the edge of the world
in these last of the last days.

IV. WINTER

Unhanked from seabed,

winter begins with starfish

in the tangle trench of kelp,

with spat between peregrine

and buzzards blown-in

for the season's turf;

sets-in with service ships

fat in the fish-eye lens

of rain-wet windows

as they anchor down

in the bay to wait out

the storm; draws near

with six o'clock pipistrelle

wraithing the dusk

for Autumn's last midge

and this strange swell of air

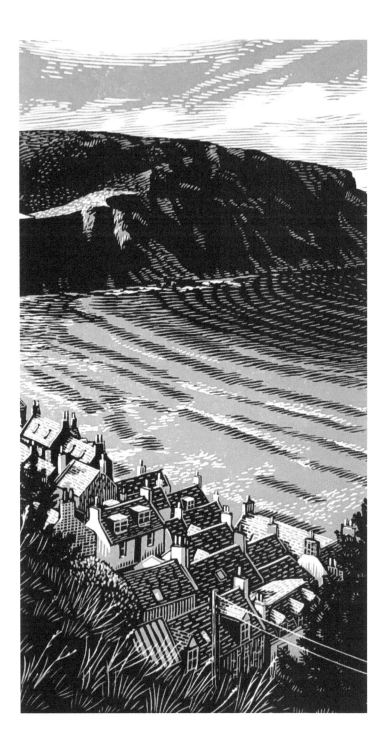

toward more darkness

than night can enclose,

while the town provokes

its own idea, drinking

hot blood in the snug.

Days forgo dawn's striving,

pebbles the warmth of a hand,

and the syncopated clock

of high water plays ragtime

with the morning,

all walking now knot-like

and wary. A late bloom

of jellyfish hawks its phlegm

into your path and lies there,

like a Sixties alien from some

original series long-lost

when they wiped the tapes.

Should they put out an appeal

then maybe, just maybe

– having lain in some attic –

an episode might turn up

to be dusted off and remind you

of better days back then.

Then again, your whole frame

of reference, here, feels dated

as the spring, with its porpoise

corpsing full-term on the beach

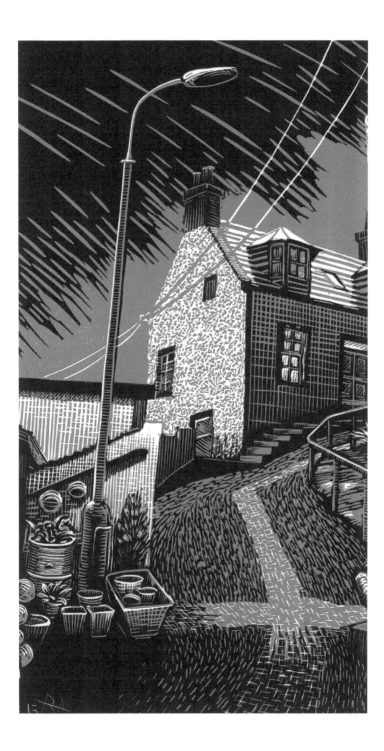

and the still-born calf of 2020
pathetic for all to see, 'til
you drag it from the crows
and sink it with stones
wedged in the gut like love.
Night hangs its blue-black bruise
out over the horizon, rolls land-
ward on the moon's Scarboro' reel,
gaffed by the tide to the bay's
own crescent. Step with me, out
from under the lamp-post glow
into a gloom oozing starlight,
as Scorpio, Ara and Capricorn
outstare the winter braes
and the land declines its own weight.
Moonlight seeps through
ink-embalmed darkness
and looking, itself, becomes
worship as we make worlds
lucid through diligence of rock:
this happenstance of slate,
obsidian hunch of the hill's shoulders
and all the subtle things of hope
that sleep in the evening's sorrow.
Amid thought and thing
advances night, and the legion
ways in which to almost say

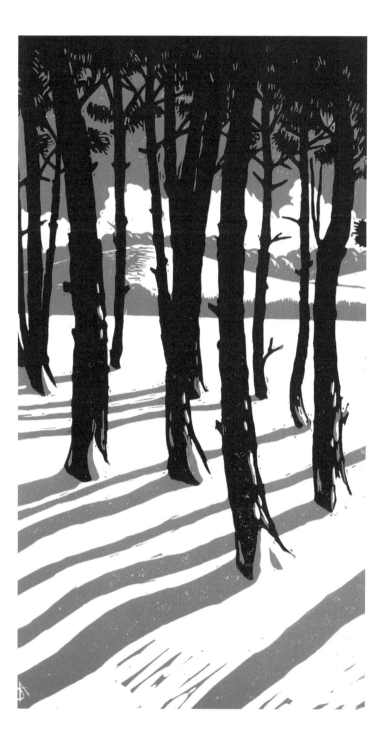

how the sea's flux arbitrates
between what we look to glean
and a meaning that refuses
word. Light as fox-toes,
snow falls before dawn,
prints absence onto the land,
draws the wren's obscure
knack of self, conjuring
its haiku from the broom.
A single morning of melt,
returns the earliest scribble
of Spring, writes back green
and black beside the primrose
and snowdrop. For, there is always
the morning and always the tide
with its dead and its flotsam,
always a man and his sheepdog
running the watches of dawn
through those nameless seasons
that squat in the unfixed space
between the named and the now.

V. MARCH/ APRIL 2020

So, it finds you on a cliff-top
at 6AM, falcon-eyed
above the scarped town,
its slow tectonic seen
from a bench beside St. John's,
its human strata visible
– there below the bungalow
bluff of new-build natives –
in the empty second-home
of Seatown's log-damp yearning.
The tide rolls in and out and in
to the bay, new daffodils gild
the path to the old graves,
a *phasie* croaks its hollow
from the cover of the gorse
and roe deer freeze on

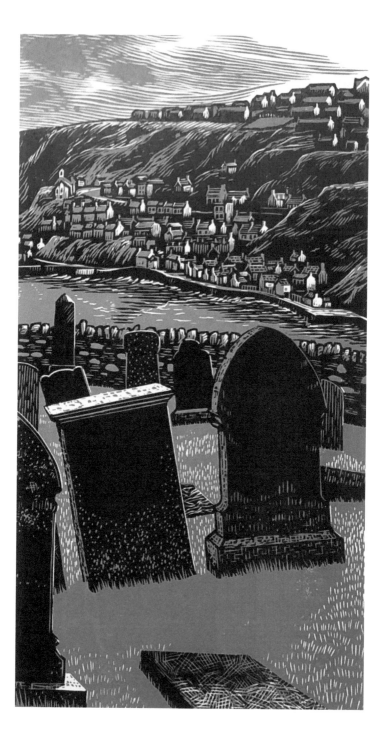

the brink of Muckle Wife.
Light comes slowly, chases
the loose change of houses sat
tight in the pocket of red cliffs,
as you haunt the old kirkyard's
mouthful of smashed molars,
taking their text for your own.
From the road, a crow raises its curse
on some car-Cained fox or badger,
while you descend from *Westerhall*
to spend an hour flush to the sea's
sullen teal, in the roaring maw
of the bay beneath Mohr Head,
the tide unloading its white noise
into the ear's quarter cran.
Two hours back, you crept across
the sand to wait in darkness
on the rumour of otter and mink
alive in the dingle of Pishlinn Burn
or Den of Findon. Nothing came
but the dawn, nothing moved
but the shore's slow reveal of kelp
and the raptor's dark covenant
with the brae. Nothing brought
nothing but Crovie's cute one-liner,
the skerry light's cry for help
and the crescent gather of wave

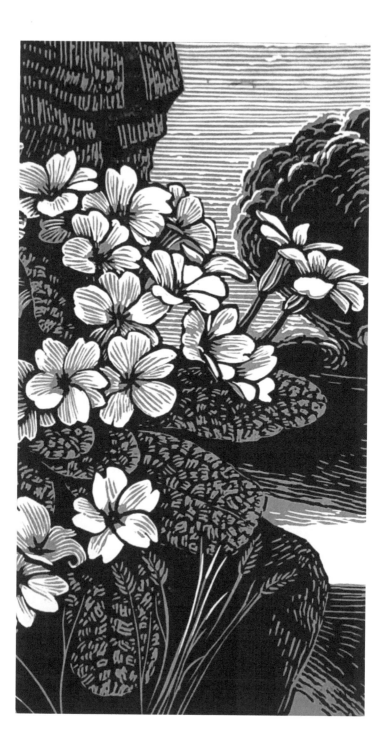

off Pecking Craig: all give-and-take
and give, then taken-back-again.
No Eastering here but a coastline
of wave-cut and stonechat;
no inscape but a buckled mind's
frailty for the April Lyrids'
random scatter of meaning
on the heaven-empty primrose.
Despite us all, spring comes
to the bay's proscenium
in a spike of wild orchids
at the foot of Castle Hill;
with sea-campion and vetch;
with violet and stitchwort,
ragged-robin and celandine;
in the flitting of wren and pipit,
irruptions of gannet on water
and the musical comedy of eiders.
The tide slackens and stills
to the morning's mood,
its lines flatten, its breathing
short. You walk out to the point
below the Head, inhale deeply
the coconut flowering of gorse
that has swept its wildfire
down the hillside. The path's,
a perfect level, narrow-gauging

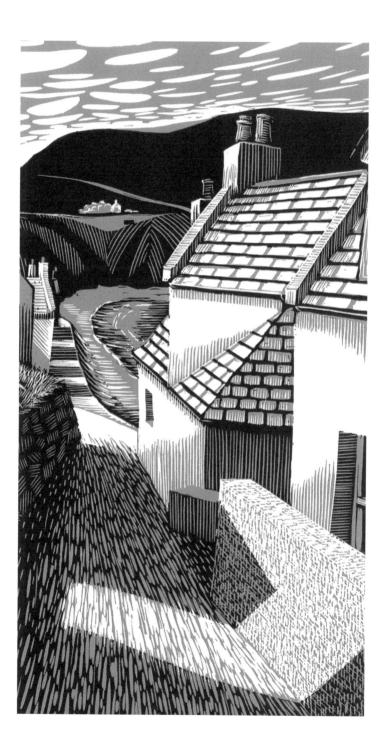

itself across well-trodden scree

as far out as Snow Craig,

to the rising cairn of stones

built, ghost-upon-ghost,

by drifters, their hand-painted

sign reading: THIS IS THE END.

ACKNOWLEDGEMENTS

I am grateful to the editors of the following organisations, journals and magazines in which sections or versions of these poems first appeared: *Caduceus Journal, Echtrai, 'Pale Fire' : Anthology of the Moon* (The Frogmore Press), *Ginkgo Prize Anthologies 2021 & 2022, Long Poem Magazine, The Manchester Review, Spelt,* and the *Scottish Poetry Library* website, I'm also grateful to An Tobar & Mull Theatre for my residency at Druimfin Cottage in early spring 2020 and The Bothy Project for the use of Inshriach Bothy during the winter of 2021.

LAY OUT YOUR UNREST